Grass-Free

Grass-Free

Confessions of a Wheat-Eater

How Go Get Thin and Stay Thin With
THE GRASS-FREE DIET

David Oxley Thompson

GRASS-FREE
THE GRASS-FREE DIET

iUniverse books may be ordered through booksellers or by contacting:

iUniverse LLC
1663 Liberty Drive
Bloomington, IN 47403
www.iuniverse.com
1-800-Authors (1-800-288-4677)

ISBN: 978 1 4917 4108 5 (sc)

Library of Congress Control Number: 2014912490

Printed in the United States of America.

iUniverse rev. date: 07/16/2014

ANCIENT EATING

Ancient eating.

There were no grasses in the ancient diet.

For some 1.8 million years, as the upright *Homo erectus,* we hunted and gathered food.

Then, about 10,000 years ago, with the agricultural revolution, grasses were introduced into the modern diet. (Grass seeds were never eaten.)

These grasses, mainly wheat, sugar cane, and corn, are responsible for the new "diseases of civilization:" arthritis, arteriosclerosis, cancer, asthma, heart disease, stroke, diabetes, Alzheimer's disease, etc.

The body just can't process grasses properly.

Grasses cause inflammation, health problems, and then an early death.

This was news to me!

Hence, *GRASS-FREE*: my discovery of what is good, and what is not good, for the body.

David Oxley Thompson
Los Angeles, 2014

Contents

PREFACE

Seek, and ye shall find.
Matthew 7:7

I grow old... I grow old...
I shall wear the bottoms of
my trousers rolled.
T.S. Eliot

I'd hit 50 like a brick wall, and then one day I saw a video of myself.

I looked terrible! I was 40 pounds overweight, with a pot belly, I moved slowly, and I generally didn't recognize myself.

Or didn't want to recognize myself. Yeah, that was me, all right. Fat and ugly and old.

What happened to the lithe animal that I once was?

Hence, *GRASS-FREE*, the product of three years of research into how to get back the body I once had when I was in college, when I'd go for a burger, coke and fries after midnight, thinking I was living the life.

Knowing I was living the life.

Of course, then, slowly, it all fell apart.

The long-distance running was hurting my knees, took a chunk of time out of my day, and left me exhausted and starving. What was going on? The years of denial began to take their toll. I was getting fat.

As I added weight I turned from long-distance running, which was too much trouble and not working, to the gym. Sure, I built muscles. But muscles under layers of fat just makes you look fatter. And boy, did I look fatter.

I hate to admit it. I looked three months pregnant.

I'd thought that exercise was the key, and I spent months honing a regime that I knew would work for me, if I only stayed with it.

And that was it. I didn't stick with it. I stopped working out and I ate poorly. Was I giving up?

Then one day I found myself within spitting distance of 200 pounds.

What was going on here? I was not aging gracefully.

And then I had an *epiphany*.

One day, I was fasting on water with a little lemon juice and cayenne pepper, to rid myself of my "toxins," when I realized that most of the toxins I was trying to rid myself of I had knowingly ingested. I was trying to get rid of the poisons in my body that I'd knowingly consumed.

I realized then that I was poisoning myself, and that I knew it.

And then...

Voilà! *GRASS-FREE*.

Let me disclaim: I am not a medical doctor, and I am in no way giving medical advice in this book, *GRASS-FREE*.

However, suddenly, and yes, it happened that fast, with my new knowledge of "poisons," I quickly dropped 40 pounds, or a fifth of my weight, when I stopped eating certain grasses.

I'd just had a hernia operation, there was no exercising, only the not eating of poisons in *The Grass-Free Diet*.

Following my own advice in this book, I've lost my "pregnancy" look, I eat sparingly, and at 5'11", 160 lbs., I have a body mass index (BMI) of 23; but most importantly, I have zero problem keeping the 40 pounds off.

But more than just losing weight, you get your health back.

Your eyes *shine*. Your skin *heals*. Your hunger *stops.* If you eat to minimize inflammation, inflammation caused by what you eat will go down.

The pain, then, that comes from inflammation-driven autoimmune diseases, like psoriatic arthritis, will go down.

So I say to you this: give *The Grass-Free Diet* a month, and see if you, too, don't have the same shock of gratitude that comes from becoming pain-free, and from having to take in all your clothes.

Avanti!

FOREWORD

There's a snake lurking in the grass.
Virgil

The body sees many grasses as poisons.

"Poison: a substance that has an inherent tendency to destroy life or impair health" (Random House College Dictionary).

When one stops eating these poisonous grasses, particularly wheat, sugar and corn, the pounds come flying off.

This is *The Grass-Free Diet*.

The Grass-Free Diet is not a prescription for what to eat or when, but rather, an approach to eating that simply avoids eating poisons. Generally, the diet avoids eating grasses. Particularly, it avoids eating wheat, sugar and corn.

The Grass-Free Diet: No poisons.

That's it.

Best of all, *The Grass-Free Diet* is like gravity: you don't have to believe in it for it to work.

To summarize: there were no grasses in the primeval diet. Grasses were introduced into the modern diet with the agricultural revolution. The body can't process grasses properly. Grasses cause health problems, and an early death.

We are naturally thin. Most people from the beginning of time were thin.

Then came the end of the Second World War. The end of WWII marks the advent of processed food, and with it, obesity.

In time, almost all processed food came to contain some form of wheat, sugar or corn, most of it genetically modified.

Now, many people who eat processed foods are obese.

Some of these people, with the help of both agribusiness and the federal government, are morbidly obese.

This is because, without knowing it, they are poisoning themselves.

It is the poisons that we eat and drink that make us so fat.

We must stop poisoning ourselves!

This book shows us how to stop poisoning ourselves!

This book shows us how to get thin and stay thin!

With *The Grass-Free Diet*:

Your skin glows.
Your head clears.
Your muscles firm.

Your stamina endures.
Your sex drive returns.

The Grass-Free Diet may save your life.

Let's see, then, how it works!

INTRODUCTION

I can resist anything but temptation.
Oscar Wilde

Once, on the putting green at Rancho Park, an old man turned to me and said something that I am blessed to repeat: "Trying is lying."

There are no excuses.

A golf score is what it is. There is no elaboration needed, no explanation required. Here's my score. No "trying" allowed.

By the same token, a weight scale gives you a number when you get on it, no questions asked.

We read in diet books the importance of motivation to achieve one's objective of losing weight.

Recently I heard of a diet web site where members put money into a pool when they join. Money is paid out to the successful dieters, paid for by the unsuccessful dieters.

It is amusing to think that this kind of money motivation would be successful over time.

That's the real issue: what will you look like next year, when everyone's gone home, and now it's just you?

This book is about getting the job done. This book is about losing excess weight and keeping off excess weight.

The Grass-Free Diet.

This book is about feeling good and looking good.

This book reviews the major issues regarding healthy eating.

This book is about how to stop poisoning ourselves. The weight loss will take care of itself.

I would like to thank the many people who led me to see that we are naturally thin, and that if we just watch what we eat and stay active, we will have no problem not only losing our extra weight, but more importantly, keeping that extra weight off.

Three people, however, deserve particular mention.

First I must thank my mother, Sylvia Thompson, both a cook and a food writer extraordinaire, of whom I have always said, "She's never made the same meal twice." More than anyone, she has taught me about healthy food. I remember shopping with her for organic food in 1967. I was 10.

Heartfelt thanks go to Mike Geary, Certified Nutrition Specialist and Certified Personal Trainer, who, among other things, taught me that 80% of what you look like is what you eat.

And finally, my thanks to Bill Phillips, whose 1975 book, *Body For Life,* showed the world (and me) that you can really change physically in no time at all. Just have a common-sense plan and stick to it.

The Grass-Free Diet:

There are no required exercises.

There are no required foods.
There is no calorie-counting.

There are three poisons to stop eating immediately: sugar, any color or form; wheat, or more particularly, gluten; and high-fructose corn syrup, made from corn. They cause inflammation, and one dies prematurely.

No poisons. The rest, as they say, is just a lot of hand-waving.

("No," by the way, does not quite mean "No." This is not a "no means no" situation. If you have coffee with brown sugar, order a salt bagel toasted with butter and cream cheese, or drink a cold Mexican coke, no one's going to call the food police on you. "No" here means "hardly ever.")

We'll explore these "foods," and then leave the decision-making up to you.

Follow this one simple rule: No poisons. (Beware of grasses.)

That being said, many "foods" are indeed poisons. Stop poisoning yourself and the pounds will fly off. And with weight loss, good health follows.

This is along the lines of the great golfer Gary Player's admonition: "Stop eating half your food."

And anyway, what more motivation do we need than to stop eating things that are killing us?

Losing a couple of pounds a week is easy. What are we waiting for?

The Grass-Free Diet.

Let's begin at the beginning with some background.

DIET

What is food to one, is to
others bitter poison.
Lucretius

David Oxley Thompson

The word "diet" means not only "an allowance of food," but as well, "food regularly consumed." It is the second definition of diet that is of interest: diet meaning "fare."

If we trace our development back 1.8 million years, back to the advent of *Homo erectus*, (upright man), we know that we ate only wild plants and animals.

Over that almost two million years, our gastrointestinal system developed to process wild foods that we hunted and gathered: meat, fish, shellfish, eggs, nuts, seeds, fruits, berries, vegetables and roots.

Then, with the agricultural revolution of about 10,000 years ago, we saw the advent of farmed plants and animals. Now the animals and plants we eat are almost entirely farmed and genetically engineered.

It is unfair to think that in such a short period of time, in the last 10,000 years (1/2 of 1% of our upright existence), that our bodies have changed to accommodate these "new" foods.

Eaton and Konner, in their *Paleolithic Nutrition*, state that, "The development of agriculture 10,000 years ago has had a minimal influence on our genes."

What are these "new" agricultural foods? These "foods" are the three main grasses: wheat, sugar and corn.

WHEAT, SUGAR, CORN

Meet the disease at its first stage.
Persius

The Three Poisons: Wheat, Sugar, Corn.

Not all grasses are poisons. Brown rice is a grass and is wonderful for you.

Not all poisons are grasses.

However...

Wheat is a grass. Gluten is in wheat. Gluten is a poison.

Wheat makes us overeat to the point of obesity.

Wheat causes leaky gut syndrome (the flooding of our body with particles of food). This inflames our joints, and generally causes havoc in our body.

Sugar cane is a grass. Cancer cells live on sugar. Sugar is a poison.

Why is sugar in everything?

Americans on average consume about 1/3 of a pound of sugar *every day*.

Corn is a grass. High-fructose corn syrup (HFCS) causes diabetes. HFCS is a poison.

HFCS is a cheap, man-made substitute for sugar.

First discovered in 1957, HFCS is highly processed, using heat, pressure, and enzymes.

Today HFCS is found in almost every processed food, from ketchup to bread.

These three grasses, wheat, sugar, and corn, today comprise almost *two-thirds* of the calories in our diet (www.truthaboutabs.com/grains).

Grasses we historically never ate. Are you kidding me? What's wrong with this picture? Gorging on poisons?

This, then, is the grass-free diet: no gluten, no sugar, no HFCS.

Avoid these poisons, lose your excess weight, and live pain-free!

GMOs

The human race is challenged more
than ever before to demonstrate our
mastery, not over nature, but ourselves.
Rachel Carson

Genetically modified foods (GMOs) have been altered, usually to make them more resilient to pests.

Dr. Joseph Mercola (www.mercola.com) in his newsletter mentions corn that has been genetically modified to produce Bt toxin. This toxin causes the stomachs of certain insects to open up, killing the insect.

Dr. Mercola suggests that peer review studies show that this toxin is found in almost everyone's body. Are *our* stomachs at risk?

The Non-GMO Project (www.nongmoproject.org) tells us that today, 88 percent of the corn fed to cows is genetically modified. GMO feed for cows gives us GMO meat, GMO milk, GMO butter, GMO cheese. GMO *us*.

I've seen estimates that as many as 30,000 food products contain GMO ingredients. This includes almost *all* vegetable oils.

High-fructose corn syrup, found in just about anything sweet, is almost certainly made from genetically modified corn.

The USDA tells us that 93% of all soybeans in this country are genetically engineered. Try and buy salad dressing without soybean oil. Try and buy an energy bar without soy protein isolate (itself a terrible product).

You are what you eat, and in you already are traces of many GMO foods.

GMO foods contains things that the body has never seen before. This gives us allergies (inflammation) that suggest that something is very wrong with what we are eating. What are the long-term effects of these "foods?"

Your guess is as good as mine.

Both organic, grass-fed meat, and wild-caught fish, are not raised on GMO corn, and hence, GMO-safe.

Food that is labelled "USDA Organic" or "Non GMO" does not contain genetically modified ingredients. Otherwise, assume that your refined food does contain GMOs, and that you are part of a very large experiment, the results of which you might only guess at.

FREE DAYS

The joy of life is variety.
Samuel Johnson

A joyous note! One day a week we rest from our diet. I rest on Sundays, when I go to the movies and eat "buttered" and "salted" popcorn.

Happiness gives us a longer, healthier life. We want to win the war, not the battle. George Washington lost his first six battles against the British. But he won the war. We want to feel good, look good and to stay that way.

That said, some call our rest day a "free" day, others a "cheat" day. Suffice it to say that no diet will work without some latitude. Our free day each week allows us to eat (within reason) whatever we choose to eat.

This allows us to stay focused on our diet the rest of the week.

With a weekly "free" day, we are telling our body that it is not starving.

If our body were to think it was starving, our body would lower our metabolism, lower our energy level, increase our appetite, and reduce both our ability to lose weight, and to keep that weight off.

Bill Phillips says in his book *Body For Life*, "The free day allows you to recover mentally and physically... Who would stick with a program that recommends never eating their favorite lasagna ever again?"

WOLF WHISTLES

You know how to whistle, don't you Steve?
You just put your lips together and blow.
William Faulkner (as spoken by Lauren Bacall)

Building muscle underneath fat just makes you look fatter.

Right now, only about 5% of Americans can see their abs.

Wolf whistles, "a typically two-note whistle made as an often unsolicited expression of sexual attention," (American Heritage Dictionary), will not come when you're overweight.

(Remember that wolf whistles, while historically directed at women, now, in our gender-neutral society, are easily directed at men.)

With simple exercise and simple eating, you will get wolf whistles!

Lean, defined bodies get wolf whistles.

Eighty percent of what you look like is what you eat.

Body fat reduction reduces the risk of type II diabetes, heart disease and cancer.

Without pushing the pencil too hard, we see that a deficit of 750 calories a day, or a deficit of 4500 calories in six days, with a 1000 calorie excess on our free day, gives us a net loss of 3500 calories for the week.

As a pound of fat is about equal to 3500 calories, that's about 50 pounds in a year lost, even with a free "binge" day each week.

The Grass-Free Diet: avoid wheat, sugar and corn, and you will get down to the weight you want and you will stay there.

No lie!

BMI

The best exercise in the world is
Pushing yourself away from the table.
Anon.

This is one of the toughest lines you'll ever read: Wolf whistles only come when your Body Mass Index (BMI) is below 25.

Your BMI is a standard (universal) calculation made from a person's height and weight.

The standard BMI categories are:

Underweight = < 18.5
Normal weight = 18.5 - 24.9
Overweight = 25 - 29.9
Obese = > 30

As we said, it's estimated that maybe 5% of Americans have a normal weight.

Exercise without a proper diet is of no use in getting the looks you're after. As we said, overweight people who work out build muscles under their fat. This only makes them look fatter.

Finally, you must not skip breakfast ("breaking the fast"). You must eat when you first wake up.

Skipping breakfast causes your body to enter a catabolic state. Rather than fueling your body from the breakfast that you eat, energy for the body comes from breaking down muscle tissue for energy and for other body functions.

Energy taken from the body is no way to build your body.

Exercise without a proper diet reminds me of the Bob Dylan line from Desolation Row:

When you asked me how I was doing
Was that some kind of joke?

Body Mass Index (BMI) Chart

Weight in Pounds

Height in Feet and Inches	100	110	120	130	140	150	160	170	180	190	200	210	220	230	240	250
4'	30.5	33.6	36.6	39.7	42.7	45.6	48.8	51.9	54.9	58.0	61.0	64.1	67.1	70.2	73.2	76.3
4'2"	28.1	30.9	33.7	36.6	39.4	42.2	45.0	47.8	50.6	53.4	56.2	59.1	61.9	64.7	67.5	70.3
4'4"	26.0	28.6	31.2	33.8	36.4	39.0	41.6	44.2	46.8	49.4	52.0	54.6	57.2	59.8	62.4	65.0
4'6"	24.1	26.5	28.9	31.3	33.8	36.2	38.6	41.0	43.4	45.8	48.2	50.6	53.0	55.4	57.9	60.3
4'8"	22.4	24.7	26.9	29.1	31.4	33.6	35.9	38.1	40.4	42.6	44.8	47.1	49.3	51.6	53.8	56.0
4'10"	20.9	23.0	25.1	27.2	29.3	31.3	33.4	35.5	37.6	39.7	41.8	43.9	46.0	48.1	50.2	52.2
5'	19.5	21.5	23.4	25.4	27.3	29.3	31.2	33.2	35.2	37.1	39.1	41.0	43.0	44.9	46.9	48.8
5'2"	18.3	20.1	21.9	23.8	25.6	27.4	29.3	31.1	32.9	34.7	36.6	38.4	40.2	42.1	43.9	45.7
5'4"	17.2	18.9	20.6	22.3	24.0	25.7	27.5	29.2	30.9	32.6	34.3	36.0	37.8	39.5	41.2	42.9
5'6"	16.1	17.8	19.4	21.0	22.6	24.2	25.8	27.4	29.0	30.7	32.3	33.9	35.5	37.1	38.7	40.3
5'8"	15.2	16.7	18.2	19.8	21.3	22.8	24.3	25.8	27.4	28.9	30.4	31.9	33.4	35.0	36.5	38.0
5'10"	14.3	15.8	17.2	18.7	20.1	21.5	23.0	24.4	25.8	27.3	28.7	30.1	31.6	33.0	34.4	35.9
6'	13.6	14.9	16.3	17.6	19.0	20.3	21.7	23.1	24.4	25.8	27.1	28.5	29.8	31.2	32.5	33.9
6'2"	12.8	14.1	15.4	16.7	18.0	19.3	20.5	21.8	23.1	24.4	25.7	27.0	28.2	29.5	30.8	32.1
6'4"	12.2	13.4	14.6	15.8	17.0	18.3	19.5	20.7	21.9	23.1	24.3	25.6	26.8	28.0	29.2	30.4
6'6"	11.6	12.7	13.9	15.0	16.2	17.3	18.5	19.6	20.8	22.0	23.1	24.3	25.4	26.6	27.7	28.9
6'8"	11.0	12.1	13.2	14.3	15.4	16.5	17.6	18.7	19.8	20.9	22.0	23.1	24.2	25.3	26.4	27.5
6'10"	10.5	11.5	12.6	13.6	14.6	15.7	16.7	17.8	18.8	19.9	20.9	22.0	23.0	24.0	25.1	26.1
7'	10.0	11.0	12.0	13.0	13.9	14.9	15.9	16.9	17.9	18.9	19.9	20.9	21.9	22.9	23.9	24.9

http://www.freebmicalculator.net

Underweight Nomal Overweight Obesity

WHEAT

I saw in vision the worm in the wheat,
And in the shops nothing for people to eat;
Nothing for sale in Stupidity Street.
Ralph Hodgson

According to *Wheat Belly*, by Dr. William Davis, Americans consume almost 150 pounds of wheat a year.

Who doesn't have a piece of toast, a bagel, a muffin, a bowl of cereal for breakfast? A sandwich for lunch? Who doesn't snack on chips, crackers, or pretzels? Who doesn't have pasta for dinner? Who doesn't eat pizza? Who can resist cake or a piece of pie for dessert?

Wheat is a grass in the monocot family Poaceae. Wheat was first grown about 10,000 years ago in the Fertile Crescent, and as such, is known as one of the early founder crops that started the agricultural revolution.

It is important to remember that *Homo erectus*, whom *Homo sapiens*, (us), is a direct descendent of, developed their gastrointestinal system over some 1.8 million years, or 90,000 generations. That's a long time.

Natural selection just doesn't work very fast, and certainly doesn't learn how to process a new kind of food (carbohydrates, particularly grasses) in only 500 generations (10,000 years). That's not a very long time.

With this understanding, there is no reaching to conclude that the body just doesn't digest grasses very well. Indeed, some of these grasses (wheat in particular) cause leaky gut syndrome (intestinal permeability).

Leaky gut syndrome occurs when little bits of what we eat get into the body undigested, causing inflammation and autoimmune diseases such as arthritis and cancer.

Autoimmune diseases are some of the leading causes of death today.

What does this all mean?

Since the end of World War II, wheat crop yields have been increased by big agriculture some ten times. During this period, we have seen Celiac disease in particular, and wheat sensitivity in general, increase some four times.

Celiac disease is an autoimmune disorder caused by the complete inability to process gluten, the gluey protein substance in wheat.

Wheat sensitivity is irritation, bloating, appetite issues, elimination issues, and general physical malaise brought on by the ingestion of wheat.

Stated simply, today's wheat, hybridized and biochemically engineered for yield or for taste, with no thought of the collateral damage being done to our bodies, is a recipe for disaster.

We start with a gastrointestinal tract that was not designed by natural selection to digest grasses, and then in the space of just a few generations we create "frankengrains" for the dinner table.

Look around you. What do you see?

What you sees is inflammation that is quite simply hard to look at. Without knowing it, people are simply poisoning themselves to death. And, of course, the government, agribusiness, and the pharmaceutical industry, with their billions of advertising dollars, makes becoming obese pretty easy.

It is thought that because wheat contains exorphins, which, like opiates, bind to the opioid receptors, we consume more food than we should. Dr. Davis says, "Elimination of wheat reduces daily calorie intake by 350 to 400 calories."

Wheat (gluten) wreaks absolute havoc in our bloodstream.

Amylopectin A, found only in wheat, raises blood sugar higher than table sugar. This means that the sugar shock from a couple of pieces of toast is equal to that of a candy bar.

In the bloodstream, either two pieces of toast, or a candy bar, converts, in the gastrointestinal tract, to about 28 grams, or one ounce, of glucose. If you don't know this, prepare to be surprised: bread has a higher glycemic index than sugar.

This means that toast causes a bigger insulin spike in the blood than a candy bar does. The need for the pancreas to produce insulin to deal with carbohydrates like bread, pasta and cookies, all day, every day, leads to insulin resistance over time.

Insulin resistance leads to type-2 diabetes. Watch what you eat!

GLUTEN

The emperor has no clothes.

Hans Christian Anderson

The Random House College Dictionary defines gluten as, "the tough, viscid, nitrogenous substance remaining when flour is washed to remove the starch."

"Gluten" is taken from the Latin word for "glue."

If you put flour in a strainer, and then run the strainer under water in the sink, you'll be left with a large ball of non-water-soluble "glue."

This gluey, rubbery mangle of proteins, mostly gliadin and glutelin, is gluten.

The body perceives this gluten as a poison.

Research suggests that gluten clogs up everything.

Gluten often causes an autoimmune response: the body attacks itself.

Before the agricultural revolution, gluten (proteins in wheat), didn't exist in our diet.

In 1975, gastroenterologist Walter L. Voegtlin self-published *The Stone-Age Diet*. In his book, Voegtlin posits that man is a carnivore, and that he ought to get most of his calories from proteins or fats.

Voegtlin felt that the human digestive system had evolved over millions of years to process proteins

and fats, the diet of the Paleolithic era. Ancient eating. Carbohydrates were rare.

Voegtlin concluded that we should avoid carbohydrates almost entirely: the body just doesn't know how to process them.

The average American now gets more than half of his or her calories from grasses, mainly wheat, sugar and corn. These foods simply did not exist until the Neolithic ("new stone age") period began, about 10,000 years ago.

The Neolithic period, with its agricultural revolution, gave us new affluence, and with it came coronary heart disease, type-2 diabetes, cerebrovascular disease, obesity, cancer.

As was said, the so-called "diseases of civilization."

Is it any wonder, then, that a large majority of Americans is overweight or obese? We're being poisoned by "frankengrains," grains (grasses) bred by the food industry for profit, with little regard to the effects that these new grains have on our health.

The Grass-Free Diet is all about calories coming from healthy fats and proteins. Poisonous food is prohibited.

Fat calories come from organic vegetables, nuts, seeds, eggs, avocado oil, olive oil and coconut oil, from grass-fed milk, butter, yogurt and kefir.

Protein calories come from vegetables, beans, nuts, seeds, grains, grass-fed meats, and wild seafood.

Carbohydrate calories are consumed in moderation. Carbohydrates contribute only small amount of energy to our body. Calories come more from vegetables, less from fruits.

Be careful with the grains. Pre-agrarian society knew not of grains. Many grains are just not good for you. With their gluten, the body doesn't know what to do with them. Remember that grains, or grasses, were not consumed at all by our hunter-gatherer forebears.

One grain, rice, particularly brown rice, with its hull, contains no gluten, has fiber to slow the digestion, and generally, with all its trace minerals, is good for you to eat.

Also, another grain, blue corn, with its many blue nutrients (like those found in blueberries), is another healthy food, much more so than white or yellow corn. And unlike white or yellow corn, blue corn is difficult to hybridize, making it GMO-safe.

With wheat we have gluten.

Gluten is a mixture of proteins found only in wheat and its family members (chiefly rye and barley).

It is the gluten in flour that gives flour its baking characteristics. Gluten, with its long molecule chains, is able to trap carbon dioxide gas, allowing

baked goods rise as they do. Gluten is the price we pay for leavened bread.

Wheat is a grass that was largely unknown to man until farming began about 10,000 years ago. The body still doesn't know what to do with this grass.

A gluten-free diet, part of the grass-free diet, will return the control of your body weight to you, and free you of your joint pain.

Some foods that contain wheat (gluten): pretzels, beer, bread, cake, candy, cereal, chips, cookies, crackers, croutons, deli meats, French fries, gravy, matzo, pasta, pie, salad dressings, sauces and soups.

Read the label.

SUGAR

Sugar is the white poison.
Matthew O'Connor

Plants produce glucose, $C_6H_{12}O_6$, through photosynthesis. Glucose is converted by plants to sucrose, $C_{12}H_{22}O_{11,}$ a plant energy reserve.

"Sugar" refers to a number of carbohydrates with the formula $C_nH_{2n}O_n$, with "n" between 2 and 7.

Historically, sugar (fructose, from fruit, or sucrose/ fructose, from honey) was quite rare, and only consumed in small amounts.

Now, however, the insulin system is overwhelmed by the amount of sugar it must process each day, five times (and more) than what it was designed for. And this does not count the carbohydrate sugar spikes in the bloodstream.

We know from Forbes ([www.forbes.com/ alicegwalton](www.forbes.com/alicegwalton)) that the average American consumes more than 120 lbs. of sugar a year (10 lbs. a month).

Is it any wonder that sugar contributes more to heart disease than fat does?

Sugar feeds cancer cells, causes diabetes, and promotes heart disease.

Sugar is addictive, as it triggers pleasure centers in the brain, much the same way cocaine or morphine does. Sugar provides only "empty calories." Sugar is in most processed food.

Although fruit contains sugar (fructose), fruit takes time to digest, as it contains much fiber. Eating

fruit in moderation is fine. (I have an apple and a banana each day).

However, avoid fruit juice. Fruit juice is just flavored water with sugar in it. *It says so right on the label.* I'll occasionally drink Gatorade, as it has half the sugar of fruit juice or sodas.

It is estimated that *ten* percent of Americans have diabetes. That's more than *thirty* million people.

The unfortunate thing is that a third of these people, as estimated by the federal government (www.cdc.gov/diabetes), don't know that they have diabetes, this insidious, ravenous disease.

The takeaway? Sugar is everywhere. Enjoy sugar at your peril.

CORN: HFCS

If you poison us, do we not die?
William Shakespeare

What, on earth, could possibly be worse for you than sugar?

High-fructose corn syrup (HFCS) is worse for you than sugar.

HFCS is made from corn.

One could argue that high-fructose corn syrup is the ultimate processed food, a product of high pressures, high temperatures, catalysts, and chemicals such as caustic soda, mercury, and hydrochloric acid.

HFCS was discovered in 1957. HFCS does not occur in nature.

HFCS was approved by the FDA in 1976. Half as expensive as sugar, HFCS is found in almost every processed food on the supermarket shelf today.

HFCS is clearly linked to stroke and heart disease.

HFCS has a different chemical structure than sugar has. It is processed differently by the body than regular sugar. Don't let anyone tell you otherwise.

There are two types of abdominal fat: subcutaneous fat, which lies over your abdominal muscles, and visceral fat, which lies under your muscles and surrounds your organs.

HFCS contributes greatly to visceral fat, fat that is by far more dangerous for the body to carry than subcutaneous fat.

It is thought that HFCS leads to overeating, as the body doesn't readily recognize the HFCS empty calories, and hence, HFCS does not sate your appetite, causing you to eat more.

One might say that HFCS is concentrated white poison.

ARTIFICIAL SWEETENERS

To the hungry soul every
bitter thing is sweet.
Proverbs 27:7

Tricking your body into raising insulin levels (this is sweet) without calories (causing fat deposition) is not a recipe for healthy living.

Artificial sweeteners have some of the lowest pH numbers, or are the most acidic, of anything ingested.

With the chlorine in sucralose (Splenda) we have what Mike Geary calls "a chlorinated pesticide." Sucralose, ($C_{12}H_{19}Cl_3O_8$), is a chlorinated sugar.

Why is aspartame (Equal) responsible for more than half of the FDA inquiries regarding food additives? Aspartame, ($C_{14}H_{18}N_2O_5$), is turned into formaldehyde when digested. The EPA says that formaldehyde (a carcinogen) is at an "elevated level" at 0.1 parts per million.

Does saccharine cause cancer? Saccharin, ($C_7H_5NO_3S$), is made from coal.

If you trick your body into thinking it is getting sweets, you are up to no good. These artificial chemicals are just that: artificial chemicals.

Chemical sweeteners are not good for the body.

After all, it's my body.

STEVIA

On his tongue they pour sweet dew.
Hesiod

Take note, then, of stevia.

Stevia is a naturally-occurring substance (found in stevia leaves), that is much sweeter than sugar, and passes through the body with no effect on the body.

Stevia presents a naturally sweet alternative to sugar or its destructive artificial alternatives.

Stevia is an all-natural, no-calorie herb, a family of plants, actually, that in parts of the world has been used for thousands of years as a sweetener.

Stevia has a sweetness 200 to 400 times as strong as sugar. I put two drops of stevia in my coffee every morning to equal the sweetness of a packet of plain sugar.

Protect your body. Stop sugar shocks. Avoid sugar if you can.

Use stevia.

CARBOHYDRATES

Bread of deceit is sweet to a man;
But afterwards his mouth shall
be filled with gravel.
Proverbs 27:17

Carbohydrates that are easily digestible raise your blood sugar as if they were indeed sugar itself.

These carbohydrates include breads, bagels, pastas, muffins, crackers, cereals: anything wheat-based.

A slice of wheat bread, once in the bloodstream, is equal to about 14 grams of sugar.

The body's response to easily digestible carbohydrates, such as wheat, is the same as its response to sugar: the body floods the blood with insulin to lower the blood sugar level in the bloodstream.

The insulin response, which rids the bloodstream of sugar, if broken, leads to diabetes, heart disease, stroke, and death.

Carbohydrates are turned into sugar in the blood with potentially deadly consequences.

Most carbohydrates just aren't that great for your body.

GLYCEMIC INDEX

Avoid fried meats which angry up the blood.
Satchel Paige

As all diabetics know, a food's glycemic index is a measurement, on a scale of 1-100, of how quickly that food raises your blood sugar. Traditionally, foods with a G.I. higher than 55 are high G.I. foods, while foods with a G.I. below 55 are low GI foods.

Blood sugar that is too high or too low can be deadly. That's why diabetics check their blood sugar at least daily.

The glycemic index of fried chicken is 95.

Foods with a high GI number include wheat, sugar, corn, white rice, potatoes, pasta, breads, carrots, beets, candy, baked goods, popcorn, beer, and refined carbohydrates where the fiber has been removed.

And anything fried.

Foods with a low GI number include most fruits and vegetables, most dairy products, beans, berries and sweet potatoes.

Carbohydrates high in fiber generally have lower GI numbers, as the fiber slows the digestion and hence the release of sugar into the bloodstream. That is why brown rice (with its bran) is much preferred to white rice, whose bran has been removed.

Proteins and fats have the lowest GI numbers, as they have little or no effect on blood sugar.

GUT FLORA

Out of this nettle, danger,
We pluck this flower, safety.
William Shakespeare

Probiotics (gut flora) are live microorganisms (bugs) that give health benefits to the host.

There are about 100 trillion bugs in the gut, or about 10 times as many bugs as there are cells your entire body.

Among other things, probiotics in the gut help digest food, and defend the body against harmful microorganisms and diseases. This defense against pathogens (germs, or bad bugs) is called "the barrier effect."

Depression, diabetes, obesity, acne, and heart disease are among the many conditions that can be alleviated by rebalancing gut flora.

One day we will find a probiotic that helps us lose weight.

Ann O'Hara and Fergus Shanahan call gut flora "the forgotten organ."

Good bugs protect us from our hungry environment. Few people die in bed of natural causes. Most people die prematurely from environmental causes.

Keeping the good bugs that live within us happy is critical. Perhaps the biggest thing good bugs do for us is to protect us from bad bugs.

Moreover, the new thinking is that bad bugs, or pathogens, not only cause obesity, but make us crave unhealthy "foods" that these pathogens live on. What are these unhealthy "foods?" Grasses: wheat, sugar and corn.

What kills good gut flora that protects us from our deadly environment? Antibiotics, sugar and artificial sweeteners.

Antibiotics kill everything. Getting the proper floral balance can take a lifetime. Don't get me wrong. My great-grandfather, a judge here in Los Angeles in 1919, died from an infection that a common antibiotic would now knock out. Antibiotics are useful tools. But so are guns.

Sugar disrupts the gastrointestinal tract by altering the balance of good bugs versus bad bugs. Bad bugs love sugar!

Finally, artificial sweeteners, with a very high pH (4), are no friends of good flora. Artificial sweeteners are worse than sugar at feeding pathogens.

DAIRY

The cow jumped over the moon.
High Diddle Diddle

The average consumption of butter in the country went down more than three-quarters from 1910 to 2000 (18 pounds per year in 1910 to four pounds per year in 2000).

The heart disease rate, however, went up four times over this same period. Maybe butter, in fact, does *not* clog arteries.

The Swiss have a much lower heart disease rate than do the Americans, even with their higher consumption of full-fat dairy foods.

The French eat more cheese, cream and butter than Americans do, but their heart disease rate is lower.

The Masai in Africa eat red meat and drink cow blood, yet with a diet high in concentrated saturated fat, they have low body fat and almost no heart disease or diabetes.

Fat doesn't make you fat. Poisons make you fat.

Dairy also contains probiotics, the importance of which cannot be overstated.

The Caucasus Mountains, just east of the Black Sea, is home to those who drink kefir and eat yogurt every day, and live to be 100 years old.

Kefir and yogurt are quite alive with healthy organisms, with something like a billion probiotics a serving.

Also, alive with the good flora that our bodies need to stay safe in a dangerous world, are milk, buttermilk, and cheese.

When I was a kid growing up, we knew that peptic ulcers were caused by over-eating and treated with Pepto-Bismol. We now know that these painful defects in the lining of our stomachs are caused by the bacteria *H. pylori*.

Antibiotics are used to treat *H. pylori*, with a success rate of maybe 75%. Studies show effective treatment rates of up to 95% with probiotics (*Applied and Environmental Microbiology*, February 2011). Bugs attacking bugs.

As was said, one day we will fill ourselves with probiotics that help us keep our weight where we want it.

Antibiotics are used to fatten farm animals. Do you think they might fatten you?

Dairy is good. Dairy fat helps keep our arteries open. Organic dairy, without antibiotics, is better.

While we're on the subject of dairy, it is important to understand the distinction between animals eating grass and people eating grass.

Cows were not meant to eat corn meal, their main staple. Unless stated otherwise, all cows are corn-fed. Their gastrointestinal tract, however, is designed to process grass, not corn.

Alternatively, for people, it's the opposite. People were not meant to eat grass. Their gastrointestinal tract is not designed to process grass.

(This is the thesis of *The Grass-Free Diet*.)

Grass-fed beef has real taste to it. Butter, cheese, milk, yogurt and kefir from grass-fed cows tastes divine. Try food from grass-fed animals and taste the difference!

Grass-fed dairy includes vitamin k2, (a vitamin D booster), CLAs, or conjugated linoleic acids, (with numerous anti-cancer and anti-inflammatory benefits), and omega-3 fatty acids (to fight heart disease and inflammation).

Grass-fed organic food: Mother Nature, nothing else.

When you eat cow raised on antibiotics and genetically modified corn, you become both fat and the GMO corn that these cows were fed.

You are what you eat!

RED WINE

Drink no longer water, but use
a little wine for your stomach's sake.
1 Timothy 5:23

Red wine has many benefits.

The antioxidants in red wine protect your body. Resveratrol, in particular, protects your blood vessels.

Equally important is red wine's impact on the bacteria in your gut.

Gut flora affect your metabolism, your skin, your weight, your immune system, your digestion, your appetite.

Antibiotics wipe out your gut flora, causing your body to have to recalibrate itself to the outside world, not to be the same again. "No man steps in the same river twice." Be careful of antibiotics.

While there are only about four pounds of bacterial organisms inside of you, as was pointed out, these bacterial cells outnumber your human cells ten to one. Most of these cells are on or about the gastrointestinal tract.

Good gut flora like red wine. Good colonies of gut flora, gut bacteria, flourish in red wine, while pathogenic (bad) bacteria do not.

Red wine decreases both systolic and diastolic blood pressure.

Red wine causes a decrease in triglycerides (fats), your LDL (bad cholesterol), and your CRP (a protein that measures inflammation).

Finally, red wine has resveratrol, another antioxidant, which makes drinking red wine in moderation another way to safely protect yourself from the outside world.

While both red and white grapes have the same amount of resveratrol, red wine is macerated: that is, the skins are soaked in the mash. White wine is traditionally made from grapes without using their skins. As resveratrol is found in the grape's skin, white wine contains little resveratrol.

Certainly a glass of red wine, when appropriate, does more good than harm to the body.

Of course, "Moderation in all things."

ANTIOXIDANTS

It is the lot of man but once to die.
Francis Quarles

Dark chocolate is in the top ten of any antioxidant list.

When oxygen interacts with something, oxidation occurs. When metal oxidizes, we call it rust. When a banana oxidizes, the banana turns brown.

Oxidation takes place when cells are born. Oxidation takes place when cells die. Oxidation is completely natural.

However, when the oxidation process goes awry, maybe 1% of the time, a chemical reaction leaves a molecule in need of an electron.

This unstable molecule is called a free radical. These free radicals are very reactive, and stabilize only by stealing an electron from another stable molecule, creating a new free radical in a chain reaction that can quickly disrupt a living cell, particularly when the damage is to a cell's DNA.

Many think that this is how cancer starts, when the damaged, or mutated, cell grows out of control, starving healthy molecules of food and oxygen, and ultimately killing the host.

Jeffrey Blumberg, PhD, professor of nutrition at Tufts University, explains:

> Free radicals are dangerous because they don't just damage one molecule. One free radical can set off a whole chain reaction. When a free radical oxidizes a fatty acid, it changes that fatty acid into a free radical, which then damages another fatty acid.

It's a very rapid chain reaction.

Free radicals come from environmental factors such as pollution, pesticides, radiation, cigarette smoke, and, of course, food.

Free radical damage accumulates with age, leading ultimately to cancer, heart disease, Alzheimer's, and death.

Free radicals are neutralized by antioxidants.

Antioxidants are molecules that are stable with or without the extra electron.

Common food antioxidants are chocolate, garlic, nuts, berries and beans.

Common vitamin antioxidants are vitamins A, C and E.

While there are thousands of antioxidants in foods, particularly in fruits and vegetables, three antioxidants are worthy of mention: the antioxidants in tea, garlic and vitamin C.

All teas contain polyphenols. Green tea has the most of these antioxidants.

A spot of tea is wonderful for the constitution.

Garlic, when crushed, releases diallyl disulfide, known to vanquish vampires.

It also is a great antioxidant.

Look for odor-free garlic pills.

Vitamin C, perhaps the ultimate antioxidant, has the added benefit of protecting your skin, the largest organ in the body.

A couple of grams a day of vitamin C is a prophylactic beyond compare.

OILS

Everything is soothed by oil.
Pliny the Elder

Bad Oils.

Almost all refined vegetable oils and margarines are made from grasses.

What inflames our veins and arteries, causing cholesterol deposits that lead to strokes and heart attacks? Refined oils.

Toxic refined oils (bleached, hydrogenated, catalyzed, pressurized, genetically modified, dissolved with hexane, etc.) did not exist before WWII. Neither did an obese population.

Polyunsaturated fats (soybean oil, corn oil, canola oil, safflower oil, etc.,) are bound together by multiple double bonds. (The prefix 'poly-' means 'many'). These double bonds are quite unstable and easily oxidized, creating free radicals in the body that cause cancer.

Processed oils have been linked to cardiovascular disease, obesity, type II diabetes, macular degeneration, irritable bowel syndrome, arthritis, cancer, asthma, psychiatric disorders and autoimmune diseases.

Refined vegetable oils, with their free radicals, cause real inflammation and cell damage to the body.

Processed polyunsaturated fats, such as soybean oil, corn oil, canola oil and safflower oil, are damaged fats, causing heart disease, obesity, and death.

Polyunsaturated fats are reactive to heat and light. They become toxic when processed and heated.

Polyunsaturated fats, (like corn oil), can be easily changed into free radicals, whereas saturated fats, (like olive oil), are most resistant to change.

Polyunsaturated fats are just not safe. When these oils are refined, they are oxidized. This gives them (and what they're in, cookies, crackers, cakes, etc.) a very long shelf life. This refinement, as we've pointed out, makes polyunsaturated oils quite inflammatory to your arteries.

Inflammation of the arteries is caused by, among other things, smoking, stress, and refined foods, including all refined oils.

Cholesterol plaque in the bloodstream protects the artery walls from injuries (inflammation) due to refined sugar, refined starches, and the refined, hydrogenated, polyunsaturated oils that are in almost all processed foods.

Uffe Ravnskov, M.D., Ph.D., painstakingly shows in his book *The Cholesterol Myths: Exposing the Fallacy that Saturated Fat and Cholesterol Cause Heart Disease*, that high cholesterol does not cause heart disease.

The simple truth is that inflammation of the blood vessels causes cholesterol deposits that lead heart disease.

Cholesterol is necessary for all animal life. Dr. George Mann, of Vanderbilt University, has said that

the lipid hypothesis of heart disease, the belief that dietary saturated fats and cholesterol clog arteries and cause arteriosclerosis and heart disease, *"[is] the greatest scam in the history of medicine."*

The best-selling pharmaceutical drug as of 2008 was Pfizer's Lipitor, with sales of $12.4 billion. What would sales for all cholesterol-lowering statins be if there were no link between saturated fats and heart attacks?

When refined oils in the blood cause artery walls to become inflamed, cholesterol plaque is deposited by the body onto these artery walls to protect and to heal them.

Too much cholesterol plaque deposited on arterial walls is called arteriosclerosis.

Refined, hydrogenated, polyunsaturated oils are found in almost every processed food and every deep fryer in the country.

The result of consuming polyunsaturated fats is hardening of the arteries. No wonder the leading cause of death (by far) in this country is from cardiovascular disease.

Heart disease was virtually unknown until the introduction of refined and hydrogenated oils into the food supply after the World War II.

Finally, know that most edible oil (soybean, corn, canola, etc.) is extracted by hexane, C_6H_{14}. Hexane is obtained by refining crude oil. Hexane is toxic at 500 parts per million, and is a known carcinogen.

Processed edible oils are just not safe to eat.

Polyunsaturated oils (refined vegetable oils) wreak havoc on the body.

These cooking oils are hydrogenated. This makes them resistant to rancidity and raises their boiling (smoke) point.

The major cooking oils are soybean oil, canola oil, safflower oil, sunflower oil and peanut oil.

These oils, extracted with hexane and other chemicals, refined with heat and pressure, really are not good for you.

Vegetable oils are quite inflammatory to the walls of your veins and arteries. This inflammation will ultimately cause the body to break down.

And stick margarine? That stuff is dynamite, slowly exploding inside you, tearing you apart. Make no mistake. Get it right. Margarine, made from hydrogenated and catalyzed vegetable oil, is poison.

Refined oils are poisons.

Look around you at teen-agers, overweight, obese. Do you really think that they are at risk because of a diet rich in saturated fats? Or are they, in fact, being poisoned, by, among other things, toxic oils?

Good Oils.

Cold-pressed virgin olive oil, cold-pressed virgin coconut oil, and churned butter, these are three good choices for healthy oil for eating and cooking.

Monounsaturated fat is quite stable, and is minimally reactive to light or to heat. These fats are connected by one single, stable bond. (The prefix 'mono-' means 'single.')

Good sources of monounsaturated fats are the aforementioned extra virgin (first cold pressing) olive oil, extra virgin coconut oil, and churned butter.

(Please note, none of our three favorite oils are grasses.)

There is no refining to get to these oils. They are either cold-pressed or churned.

Olive oil, coconut oil and butter are wonderful, safe fats for you.

These monounsaturated fats are the most stable of oils, and the least reactive to heat and light. These oils are much more stable than polyunsaturated fats (vegetable oils).

Monounsaturated oils generally do not interact with the body. Plus, they taste great!

Three good oils:

Cold-pressed olive oil: Olive oil is a monounsaturated fat. As such, it reduces heart disease.

Cold-pressed coconut oil: Coconut oil contains mostly medium chain triglycerides (MCTs), which people largely lack. MCTs strengthen the immune system, and may slow (or even reverse) arteriosclerosis.

Churned butter: Organic grass-fed butter contains wonderful nutrients, including omega-3s for metabolism, vitamin K2 for healthy blood, and conjugated linoleic acid (CLA) for cancer protection. Of course, everything tastes better with butter!

These oils are good to cook in, particularly as they all have lower smoke points, so that your food is not overcooked.

The safest fats to cook with and to eat are the saturated fats. They are not as reactive to heat, and thus create fewer free radicals when heated.

Healthy fats include nuts and seeds. Remember that nuts are seeds with a nutshell, the nutshell being the "fruit" of the plant with the nut inside.

Examples of healthy nuts are walnuts, cashews, almonds, pecans, and macadamia nuts.

Healthy seeds include pumpkin seeds, sesame seeds, sunflower seeds, chia seeds, and flax seeds.

Finally, peanut butter, avocados, and dark chocolate, are all healthy, stable, good fats to eat

(in moderation, to those without allergies). Bon Appétit!

Eskimos lived on a steady diet of seal fat, whale blubber and organ meat. This population, subsisting on much animal fat, hardly knew heart disease, diabetes or obesity.

Eskimos didn't eat processed foods.

Pacific Islanders got as much as two-thirds of their calories from saturated coconut fat.

Prior to eating processed foods, Pacific Islanders knew almost no fat-related diseases.

Mediterranean diets, as much as 70% fat, didn't historically create fat people until processed foods came along.

Fat doesn't make you fat. Processed fat makes you fat.

VINEGAR

Wine and the sun will make vinegar without any shouting to help them.
George Eliot

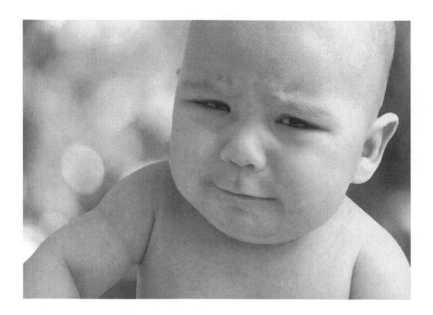

George Eliot was right.

Vinegar, CH_3COOH, is made from ethanol (alcohol), and a common bacteria (acetic acid bacteria).

Of course, one can make alcohol from just about any carbohydrate: grapes, apples, dates, rice, raisins, honey.

In the first fermentation process, sugar with yeast (a fungus) is turned into alcohol:

$C_6H_{12}O_6$ (glucose) \rightarrow 2 C_2H_5OH (ethanol) + 2 CO_2 (carbon dioxide)

In the second fermentation process, ethanol with acetobacter (a bacteria) is converted into vinegar.

2 C_2H_5OH (ethanol) + O_2 (oxygen) \rightarrow 2 CH_3COOH (vinegar) + 2 H_2O (water)

Apple cider is made from the juice of apples. Hard apple cider is made from apple cider and yeast. Apple cider vinegar is made from hard apple cider and acetic acid bacteria.

Vinegar, first made from wine about 7000 years ago, historically has been used to treat infections, reduce fevers, cure ulcers, relieve constipation, preserve foods, prevent influenza, ease stomach ailments, alleviate acne, minimize inflammations, give satiety, and, with honey, control coughs.

But the real reason to take organic apple cider vinegar at is that vinegar has been shown to dramatically lower blood sugar levels. High blood

sugar levels cause diabetes, heart disease, stroke, and death.

Nothing good comes from too much sugar in the blood.

A slug of apple cider vinegar before dinner curbs your appetite and helps keep your blood sugar in check. I take my apple cider vinegar raw. Others mix the vinegar in a glass of water with a couple of drops of stevia.

ACIDOSIS

Opposites are cures for opposites.
Hippocrates

The body functions best at a particular temperature: 98.6 F.

Similarly, the body functions best at a particular acidity: 7.4 pH.

The pH of tap water is 7.0, midway between the pH scale of 0 (very acidic) and 14 (very basic).

The pH of carbonated soft drinks is 5.5 (acidic), and the pH of grapes is 8.5 (basic).

Just as one can slip into a coma with a temperature above 105 F., a coma is probable with a blood pH below 6.8.

Wheat, sugar and corn all have acidic pH's (www. rense.com).

The body lowers its acidity using the calcium in bones: bones are dissolved to make the body more alkali. Osteoporosis is exacerbated by eating acidic things such as wheat, sugar and corn.

Avoiding these poisons lessens our chances of having brittle bones that, as we get older, break easily.

Surprisingly, a lemon, with its pH of 4 outside the body, an acid, becomes a pH of 10 inside the body, a base.

Sweet lemon juice is made with an organic lemon, squeezed into four ounces of water, with two drops of stevia.

Sweet lemon juice lowers the acidity of the blood, cleanses the body of toxins, and settles the stomach.

I always have a glass of *sweet lemon juice* before my kettlebell swing.

GLYCATION

And when he's old, cashier'd.
William Shakespeare

How'd we get old?

One of the ways we get old is through glycation.

Glycation is the random bonding of a sugar molecule with either a fat molecule or a protein molecule.

Exogenous glycation occurs when French fries are browned with sugar, when meat is barbequed on the grill, when soft drinks are colored with caramel.

Endogenous glycation occurs when sugar randomly binds with fat or protein in the blood.

These new glycation molecules are called Advanced Glycation End-products, or AGEs.

These rogue molecules, AGEs, have been linked to cancer, heart disease, Alzheimer's disease, arthritis, you name it.

Wheat is immediately converted to sugar in the blood.

AGEs attack the body, leading to the degeneration of the body's tissues, particularly the cartilage, which cannot reproduce.

We are subject to these AGEs all of our lives.

What do we call unremitting joint pain and inflammation, particularly of the knees, hands and hips? Arthritis.

Arthritis, "inflammation of the joints" (Merriam-Webster Dictionary), occurs when the body attacks itself. Arthritis can be slowed, but it can't be reversed.

My grandmother lived to be 100. She had a wonderful piece of advice: "David, don't ever get old."

As an alternative to that good thinking, I strongly recommend consuming minimal amounts of wheat, sugar or corn, so that AGE products don't quickly compromise your body.

FIBER

A wise man should consider that health
is the greatest of human blessings.
Hippocrates

Carbohydrates, be they sweets, fruits or starches, become saturated fats in our bodies if not immediately used for physical activity.

Soluble fiber slows digestion, slows the emptying of the stomach, makes us feel fuller, and helps us control our weight. Also, most importantly, soluble fiber helps control blood sugar levels.

Fiber also helps your body stay moving and not stopped up. Disease needs privacy to cause trouble. Your body will stay healthy if you let it.

Grasses are known to clog up the body. You will be amazed at how *regular* you become once you stop eating grass!

(The fact is that a grass-free diet eliminates (!) regularity issues. That alone is reason enough to throw out any questions about what's what.)

The worst carbohydrates are those with little soluble fiber. They are the white starches, which immediately raise the blood sugar in the bloodstream: cereals, potatoes, pastas, white rice, wheat, sugar, corn, etc.

Carbohydrates with much soluble fiber are avocados, beans, berries, peas, Brussels sprouts, broccoli, apples, carrots, green beans, pears, and prunes.

Some cancer-fighting cruciferous vegetables are cauliflower, cabbage, Brussels sprouts, bok choy, watercress, and broccoli.

Cut them up and eat them raw, with a dip. You're set!

A good simple dipping sauce, or vinaigrette, is vinegar (or lemon juice) and oil, with salt and pepper, and maybe a little mustard or garlic.

I use balsamic vinegar, extra virgin olive oil, and a dash of sea salt.

Julia Child tells us, "I opt for the dry martini proportions, one-to-five; but you must judge this yourself..."

(I must confess to a one-to-one preference. After all, it's called "oil and vinegar dressing" for a reason.)

THE KETTLEBELL SWING

The omnipresent process of sex...
is woven into the whole texture of
our man's or woman's body.
Havelock Ellis

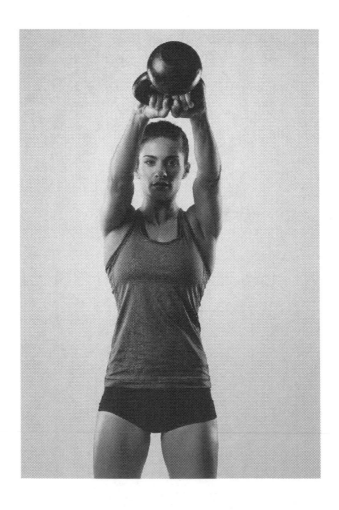

Our bodies are designed for stop-and-go physical activity.

Consider the physiques of marathoners versus sprinters. Which would

you rather resemble? An anemic marathoner or a built sprinter?

Working out for long periods of time fills your body with poisons.

Mike Geary recommends "five minute high intensity workouts, six days a week" (truthaboutabs.com/perfect-workout-length.htm).

The best exercise for core strength and conditioning is the kettlebell swing.

The kettlebell swing hits all the major muscle groups. With a kettlebell, (a cannonball with a handle), swung between your legs, then up parallel to the sky, you truly have an exercise for the ages.

Swing the kettlebell when you first jump out of bed in the morning for maximum impact. First make and drink a glass of *sweet lemon juice*. This will give your body the lubrication for a quick, tough workout.

Then comes the kettlebell swing. This won't be hard. Breathing is the key: blow out hard as you swing up, inhale hard as you swing down.

Dr. Ben Fung (www.kettlebelltherapy.com) says, "The average kettlebell swing yields 4-6x the

weight of the bell." Thus, a 35 lb. kettlebell, when swung, weighs as much as 200 lbs. at the bottom of the swing.

Remember, the secret to the exercise is to thrust at the hips, the shoulders swinging the kettlebell, the core of the body quiet.

The Kettlebell Swing exercise is 10 breaths getting set, 20 kettlebell swings, then 60 slow, deep breaths, eyes closed, sitting in the lotus position (cross-legged, wrists resting on knees, the weight of your head on your spine).

Women often use a 15 lb. kettlebell; men may choose a 25 lb. kettlebell.

The kettlebell swing keeps your body strong and your posture perfect, while walking everywhere keeps your heart strong and your breathing perfect.

The kettlebell swing makes you The King (or Queen) of the Mountain!

MEDITATION

Where there is peace and meditation,
there is neither anxiety nor doubt.
Saint Francis of Assisi

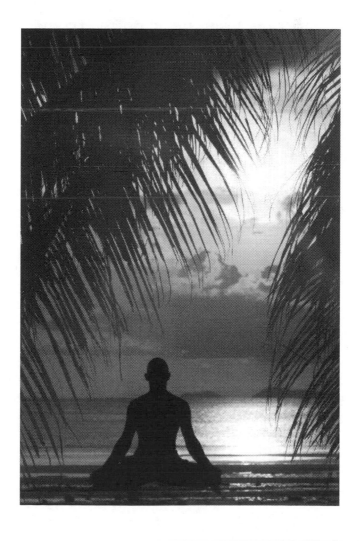

True relaxation releases muscle tension and slows down the breathing.

Relaxation techniques are used to treat stress-related ailments, such as hypertension, insomnia, asthma, chronic pain, arrhythmia, and anxiety.

The physiological effects of relaxation include a lower heart rate, lower blood pressure, and lower cortisone levels.

The best form of relaxation is meditation. The essence of meditation is quiet awareness, being in a deep form of rest.

Meditation gives moments of stillness that balance a life of activity.

Meditation allows us to practice detachment, taking ourselves outside of our everyday thoughts.

Meditation can be included as an essential part of our fitness routine. Sitting quietly on a workout bench for just one minute after a workout makes a big difference. A quiet moment of gratitude gives back a lot.

The aim of meditation is to focus inward and to forget about the body, and thus, to allow the body to become completely relaxed.

Sit comfortably in the lotus position. The legs are crossed, the palms lie up, the wrists rest on the knees. Let thoughts come and then let thoughts go.

Focus on your breathing, in and out, in and out.

This is the heart of meditation: letting go of thoughts, clearing the mind by letting go of the mind's obsessive rumination.

Soon the thoughts dry up, and you have a quiet of mind.

Twenty minutes of meditation, morning and night, will give you a sense of personal power, without question, like nothing else.

Meditation, like prayer, takes you closer to your god.

CONCLUSION

Of a good beginning cometh a good end.
John Heywood

Ancient eating is like learning how to ride a bike. Once you get it, it's easy!

More *GRASS-FREE* ideas can be found at www. grass-free.com.

Limit your carbohydrate intake to what your body needs. You can't see your abs if you're overweight.

Remember that wheat or sugar is in just about *every* processed food.

Those of us looking to lose weight and to live well might have fries on a 'free' day, but be aware: the wheat is in the coating.

Healthy fats are grass-fed butter, avocados, olive oil, coconut oil, seeds, nuts, and eggs.

Healthy carbohydrates are fruits and vegetables. Remember that rice and oats do not contain gluten, and that fermented food is good food.

Healthy proteins are vegetables, beans, nuts, seeds, wild seafood, and range-fed meat and fowl.

Organic food is grown without man-made pesticides, fertilizers, hormones, antibiotics, and is not genetically modified. Organic food is unrefined and unprocessed, in its natural state.

Eat organic livestock, as they must graze off of pastures in the summer. Alternatively, do not eat farm-raised fish, as they live in chemicals and filth.

Particularly fattening are chemicals in the environment called xenoestrogens.

Xenoestrogens throw our hormonal system out of whack and help make us fat. They're everywhere, in soy products, hormones and antibiotics fed to animals, food packaging, chemicals in processed food, pesticides.

Most of the unprocessed food in a market is found against the wall: fruits, vegetables, meats, fish, dairy.

Alternatively, processed, salted, and sweetened foods tend to be at the center of the store. Don't go down that aisle!

Ideally, every primeval meal ought to be made up of a lean protein, a fibrous, complex carbohydrate, and a saturated fat.

Much more important than the mix of food groups (proteins, fats, and carbohydrates) is the amount of calories consumed, that the foods are not processed, and that one's nutritional needs are being met.

Whole fruit, eaten slowly, fills us up and curbs our hunger, provides important fiber for digestion, and minimizes the release of insulin.

Fruit juice, on the other hand, has no fiber, no eating time, is high in calories, doesn't satisfy your hunger, and spikes the blood sugar. Not good.

Instead, drink *sweet lemon water*, clean water with fresh-squeezed lemon juice and two drops of stevia. Your body will love you!

Vitamin D, from the sun, may be as important as any factor in regulating your health. Get some sun every day!

Vitamin supplements are personal. Each day I take a four of grams of vitamin C, a multivitamin, fish oil, cinnamon, garlic, aspirin, and probiotics.

My kitchen, though small, has all the essentials. These simple, organic, grass-fed, cage-free, wild foods are:

Nuts, Seeds, Eggs, Fish, Chicken, Beef, Broccoli, Cauliflower, Garlic, Avocados, Sweet Potatoes, Mushrooms, Onions, Berries, Coconut Oil, Whole Milk, Butter, Yogurt, Peanut Butter, Dark Chocolate, Water, Coffee, Tea, Red Wine, Honey, Stevia, Ground Pepper, and Sea Salt.

Water is a necessity, at a recommended eight glasses a day. (I might say that eight glasses of any liquid works for me.)

And finally, though meditation is great, a 20-minute siesta is wonderful!

Thoughts are things. With a smile on your face, know that you've got it all! Choose to be happy! Happiness gives good health. Choose to laugh! Your happiness becomes reality as you give to get. Happiness is contagious.

Good luck and Godspeed to you and yours!

REFERENCES

International Labeling Laws

Center for Food Safety (2013)

centerforfoodsafety.org/issues/976/ ge-food-labeling/international-labeling-laws#

Accessed January 14, 2014

On Communication between Gut Microbes and the Brain

Current Opinion in Gastroenterology 28:557-562 (2012) Forsythe P, Kunze WA, Bienenstock J.

Major Crops Grown in the United States

Environmental Protection Agency (2013)

epa.gov/oecaagct/ag101/cropmajor.html

Accessed December 8, 2013

Glyphosate-Resistant Weed Problem Extends to More Species, More Farms

Farm Industry News (2013)

www.farmindustrynews.com/herbicides/ glyphosate-resistant-weed-problem-extends-more-species-more-farms

Accessed December 13, 2013

Completed Consultations on Bioengineered Foods

Food and Drug Administration (2014)

accessdata.fda.gov/scripts/fcn/fcnNavigation. cfm?rpt=bioListing&displayAll=false&page=1 Accessed March 3, 2014.

Accessed March 3, 2014

Corn Production: Common Corn Questions and Answers

Iowa State University (2011)

agronext.iastate.edu/corn/corn-qna.html

Accessed June 15, 2013

Long-term Ecological Impacts of Antibiotic Administration on the Human Intestinal Microbiota

ISME Journal 1 56-66 (2007) Jernberg C, Lofmark S, Edlund C, Jansson JK.

The "Non-GMO Project Verified" Seal

Non-GMO Project (2014)

www.nongmoproject.org/learn-more/ understanding-our-seal/

Accessed May 9, 2014